For David Falkner
from
Armstrong

SIXTY
PHOTOGRAPHS

TO CELEBRATE
THE SIXTIETH ANNIVERSARY
OF ALFRED A. KNOPF, PUBLISHER

SIXTY PHOTOGRAPHS

ALFRED A. KNOPF

ALFRED A. KNOPF NEW YORK 1975

THIS IS A BORZOI BOOK
PUBLISHED BY ALFRED A. KNOPF, INC.

Library of Congress Cataloging in Publication Data

Knopf, Alfred A. [Date] Sixty photographs.

1. Artists—Portraits. I. Title.
NX90. K56 779'.2' 0924 75-8235
ISBN 0-394-49892-5 ISBN 0-394-73097-6 pbk.

Manufactured in the United States of America
First Edition

Contents

Preface

My first camera was what Eastman called, I think, a Bulls Eye Number 2—a box affair a few degrees above the Instamatic of the day, the Brownie. Eastman's great advertising slogan, familiar to any amateur snapshotter, was "You push the button: we do the rest." But "the rest" often meant only developing the film, for I can remember making prints on Velox paper under the Welsbach ("mantles" they were called) lights over the breakfast table in the front ground-floor room in our house on Convent Avenue at 148th Street—number 145 it was. I remember too making a darkroom of our cabin on an overnight boat trip with a favorite uncle from Boston to Portland, Maine. I must have used a red light of some sort in the darkroom, developed in a small "tank" or possibly a wash basin, "fixed" the film with something called "hypo," washed it, and hung it up to dry—clipped to a line with laundry pins.

In early 1912 when I took off for six months or so in Western Europe—chiefly Germany, where I was supposed to learn the language, and Britain—my stepmother gave me a folding Kodak, *i.e.*, one with a bellows. It took quite good pictures when used correctly (3¼ x 4¼ inches in size). I no longer did and never resumed doing any developing and printing. But then Pat was born; like most kind fathers I wanted good likenesses of a creature who was constantly in motion. Therefore, I needed a much more expensive Kodak, something with a much faster shutter and lens. I was selling our books through a good deal of the East, including Rochester, and there the very friendly buyer at my biggest account (I don't remember his name, but the store, I think, was Scrantom's) got me a Graflex at the trade discount. With this you were able to see on ground glass exactly what you were taking.

Sometime in the twenties I bought a Bell & Howell movie camera, and this accompanied me on all my trips abroad until, on a skiing holiday in Norway, where I had gone chiefly to visit Sigrid Undset, I saw two Germans

handling and heard them discussing the features of the Leica—a name of which I was completely ignorant. This, I think, was early in 1935. At home I found that Carl Van Vechten owned a Leica with which he was just beginning his distinguished career as a serious portraitist. I bought one and took it on my first flight to California. Since then it has been a constant companion, and I have bought two more—an M3 and a Leicaflex, which I use today. I am still a snapshotter, have never learned even to use flash, and no one knows better than I that unless you process your own films, making use of all the chemicals available to modify the density of your negatives, and make your own prints as well, the results will usually be far inferior to what your equipment is capable of producing. In the old days you pretty much got a picture or you didn't. Today there seem to be countless gradations between a really accurate reproduction of what you saw when you made the exposure and complete failure. The better your equipment the greater the number of slight but sometimes serious mistakes you can make.

And I am lazy—seldom willing to take a little extra trouble in posing my subject and frequently believing what is most certainly not true—that it is wasteful to take half a dozen or more exposures in fairly quick succession. The pros who have taken me, I've noticed, frequently use up the whole of a roll—thirty-six exposures.

An old saying has it that beauty lies in the eye of the beholder. This is no doubt sometimes true, but by and large my pictures of people derive their interest almost always from the subject and not the photographer.

SIXTY
PHOTOGRAPHS

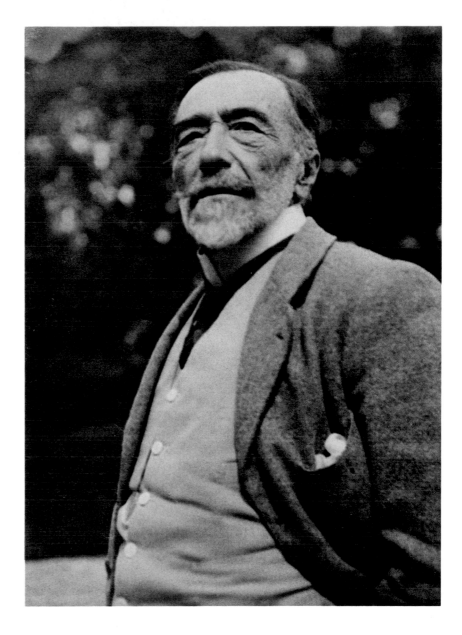

Joseph Conrad

It was certain that we would want to see Joseph Conrad when we went to London for a longish visit in the early summer of 1921. Richard Curle, a young writer, was one of Conrad's earliest admirers, and Conrad was devoted to him. I think we rented a car and were driven with Curle to Conrad's home—Capelstone—in a village in Kent near Canterbury. I took this snapshot as we were leaving.

John and Ada Galsworthy

I spent more than a month in lodgings in York Street off Holmes's Baker Street in the early summer of 1912. I had been in correspondence with Galsworthy for a long time as a result of writing an essay on his novels which I offered in competition for an undergraduate prize at Columbia (I did not win it), and I hoped to meet the man whose work I had admired so greatly and for so long. To my gratification, I was invited to spend a night with Ada and J. G., as she always called him, at their tiny cottage, Wingstone, on the edge of the Devonshire moor. This was taken in the bright sunlight of the following morning before I went on my way.

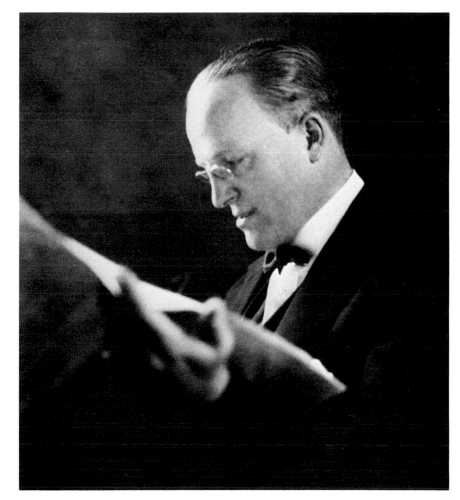

Hugh Walpole

Well before we made our first Atlantic crossing, Blanche and I had become very good friends of Hugh Walpole. In London, Hugh invited us to a very large and formal party, which I'll always remember for two reasons. I had had a new dinner suit made for me by Henry Poole, the celebrated London tailor, and was wearing it for the first time that evening. I have never enjoyed men's formal evening clothes, but this jacket seemed remarkably comfortable, and I said to Blanche, "That's how a dinner jacket ought to be cut." Alas, in the course of the evening I happened to look for the label in the inside breast pocket and there read not my own name but that of some titled Spanish grandee! And then: Lauritz Melchior, Hugh's protégé, was at the beginning of his career as probably the greatest heldentenor of our time and had just made his first recording. He found a Gramophone and instantly started to play it. Hugh took the disk off. Melchior put it on again. Hugh stopped it. And so it went, it seemed to me, for almost the whole evening. Not exactly relaxing...

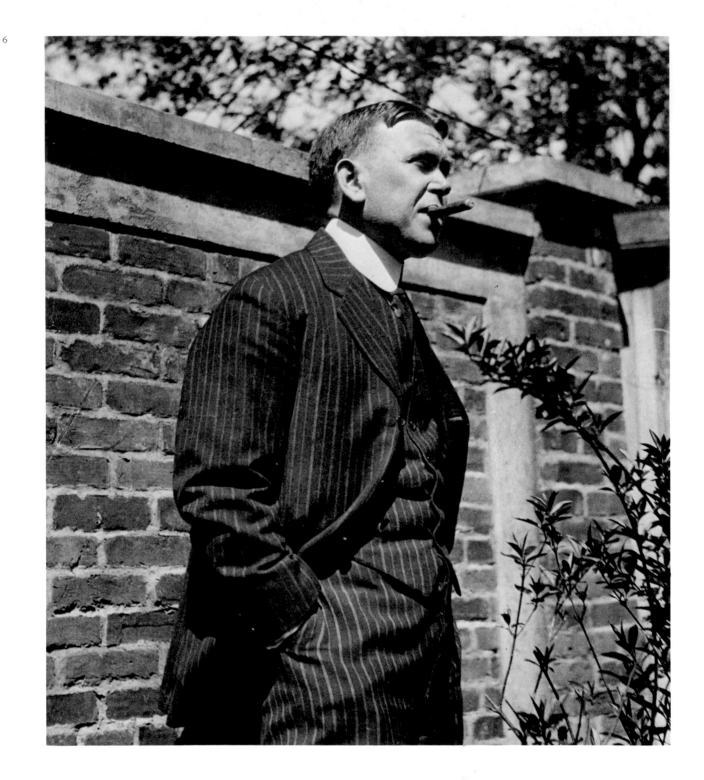

George Jean Nathan

It's surely Nathan and he's surely
young, and this must have been
taken soon after we first published
him, prior to 1923. But where? It
looks like a ship, but that doesn't
help me a bit.

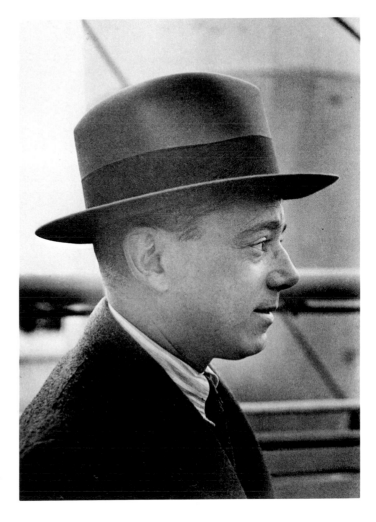

Henry Mencken

Henry Mencken was very photogenic—one seldom took a poor snapshot of him,
and I took many over the years of our association. His home in Baltimore for nearly
all his life, except for the few years of his marriage to Sara when they lived in an
apartment on Cathedral Street, was the red brick house with the white marble
steps that led up to the door at 1524 Hollins Street. It had a backyard, along one side
of which Henry had built a brick wall with his own hands. In its center he had
inserted a head of Beethoven. Here he is standing next to this wall.

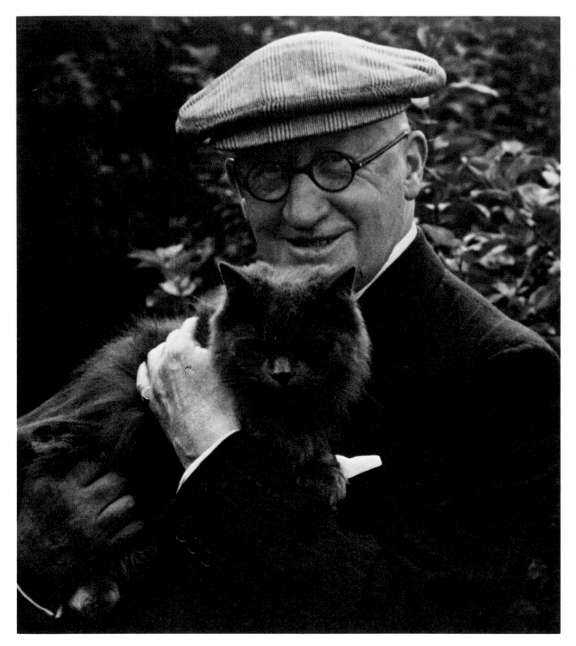

Ernest
Newman

In 1946 Ernest Newman and his wife Vera lived at Tadworth, a small village in Surrey, England. Many a time I took the train at Charing Cross to spend the day and often the evening with them. A separate building contained Ernest's working library, a piano, a pool table, and a heater of some kind. He was very, very fond of his cat.

Witter Bynner

Witter Bynner in Santa Fe was the monarch of all he surveyed. I had known Witter when I worked for Mitchell Kennerley, who published some of his books, but he came over to us about 1919. So whenever I went west by the *Chief* I stopped off if I knew Witter would be there (he spent a great deal of his time in his house in Old Mexico and traveled extensively in China). This was taken in Santa Fe and seems to me to suggest the robust, hearty, extrovertish fellow that Witter was.

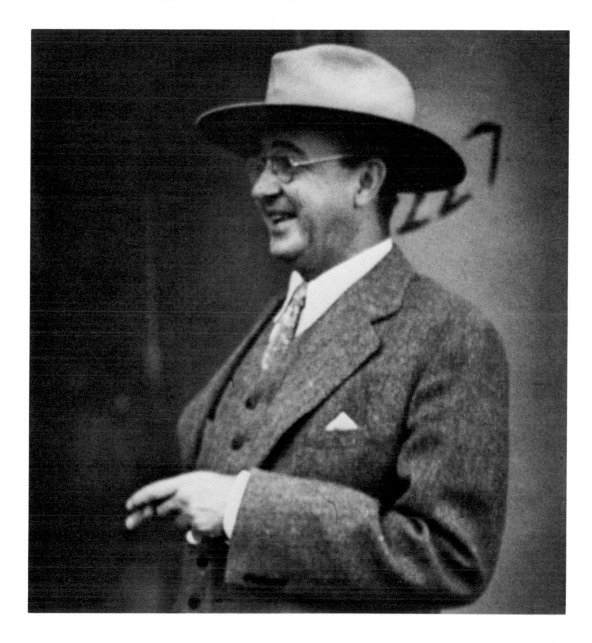

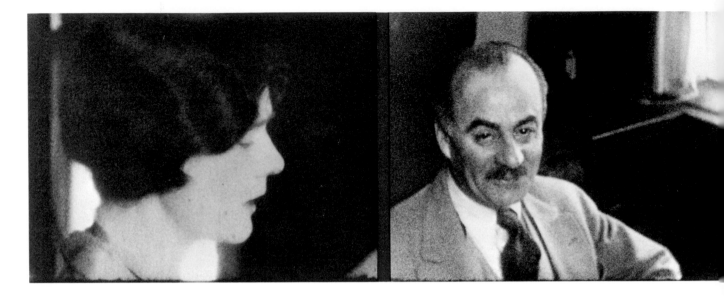

Elinor Wylie Kahlil Gibran

Four of these likenesses are not among my best—Elinor Wylie, Kahlil Gibran,
Willa Cather, and Max Beerbohm. These are stills taken from my very amateur
movies. Presumably all were made during the years that preceded my discovery of
the Leica in 1935. Elinor died in 1928, Gibran in 1931. Why I never took Willa
Cather with my Leica I can't explain, as she seemed willing enough to subject
herself to my Bell & Howell. I think I caught her here in a bit of characteristically
animated conversation with Blanche at the latter's office desk. Sir Max turned up
one day at noon (it was a very dark noon) and he swaggered halfway across Bedford
Square (where our ill-fated London company had its offices) to oblige me. The
result is unmistakably "Max" the incomparable.

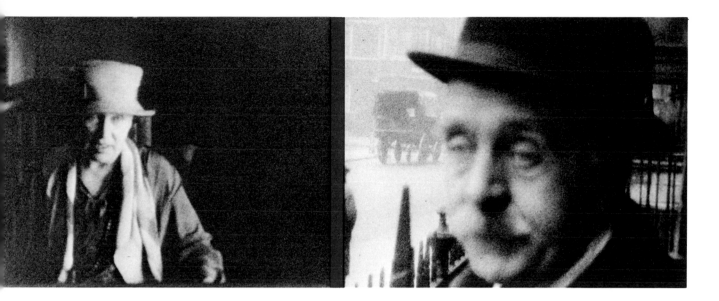

Willa Cather Max Beerbohm

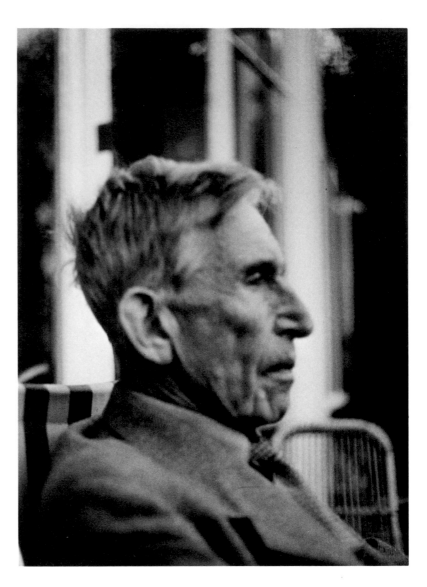

Leonard
Woolf

I saw Leonard Woolf for the first time when, sometime in the mid-twenties, I called on him at the offices of his publishing house, The Hogarth Press. My chief recollection of that visit was our talk about a phonograph in the room—an old-fashioned one with a great horn *à la* the old His Master's Voice. Woolf said it required a special needle—one of fiber, I think—but as an ancestor of hi-fi it was far superior to anything on the market. More than thirty years later I saw him for the last time. Woolf, then retired, and I think at least eighty, came to a dinner party in the country. There was a long twilight, and my eyes clearly did not get this one in proper focus.

We published Arthur Waley's *170 Chinese Poems* in 1919, the first book of his to  appear over here—if not indeed his first book. I take great credit for this, since Waley over and over again proved his genius as a scholar and translator from the Chinese. After a few more books Waley left us. He had changed his English publisher because he found one near the British Museum where he worked, and this was a convenience he could not resist. We met again in the summer of 1939 when he visited me at the flat I had rented on Jermyn Street.



Arthur Waley

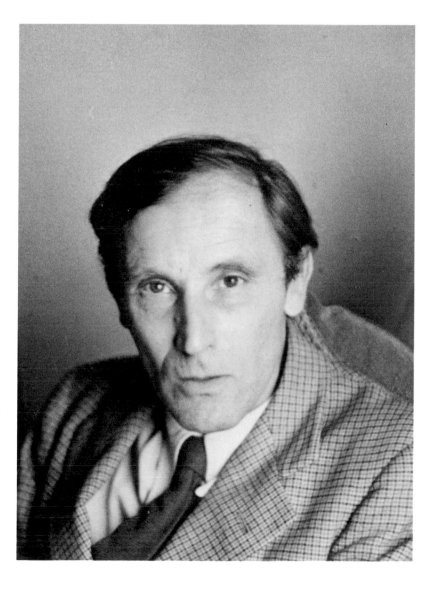

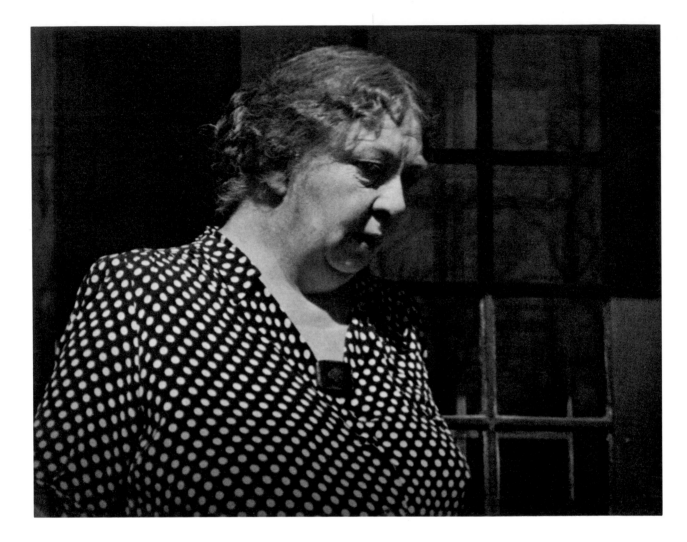

Sigrid Undset

Sigrid, whom Blanche and I had both visited in Norway and who shared our great
admiration for Willa Cather's work, was by the time the war came an old friend.
She arrived, with her son Hans, via Siberia, the Pacific, and the whole width of the
U.S. She settled in a flat in the Columbia Heights section of Brooklyn and came
often to Purchase. She impressed strangers as dour, but if the conversation turned
to something that struck a truly responsive note in her (Emerson or Thoreau, per-
haps), she suddenly became the life of the party.

Thomas Mann and Hermann Hesse

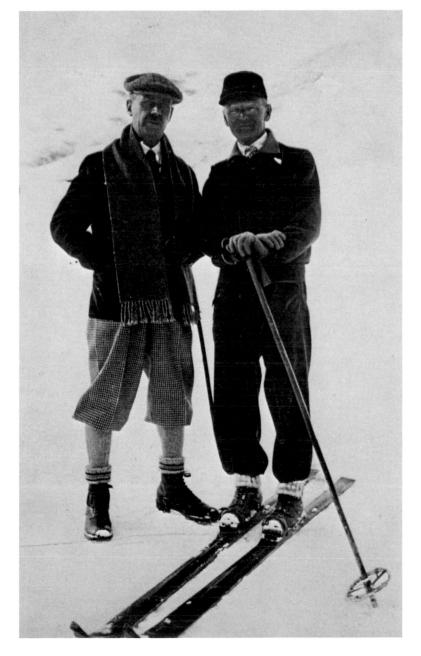

I paid my last visit to Germany in the winter of 1932. The Manns still lived in their big house in Munich, but he and Katia, when I got there, were on a holiday at Chantarella, a short way up the mountain from St. Moritz. So I went for a couple of days to that beautiful resort where I had a good visit with Tommy and Katia, who came to my hotel for lunch and dinner with me. The Hermann Hesses were there too (what a pity I did not arrange to become Hesse's American publisher then and there, but the publisher doesn't live who hasn't made similar mistakes, though few ever talk about them).

Heinrich Mann

While it has always seemed unwise to me to publish the work of brothers or sisters or sons or daughters of important writers already on the list, I somehow made an exception in the case of Thomas Mann. When Tommy recommended the great novel on Henry IV of France on which his older brother was working we followed his advice and published, in 1937 and 1939 respectively, *Young Henry of Navarre* and *Henry, King of France*. By October 1940, when Heinrich had left Europe, it was natural for him to find his way to my office —where he sits opposite me at my desk.

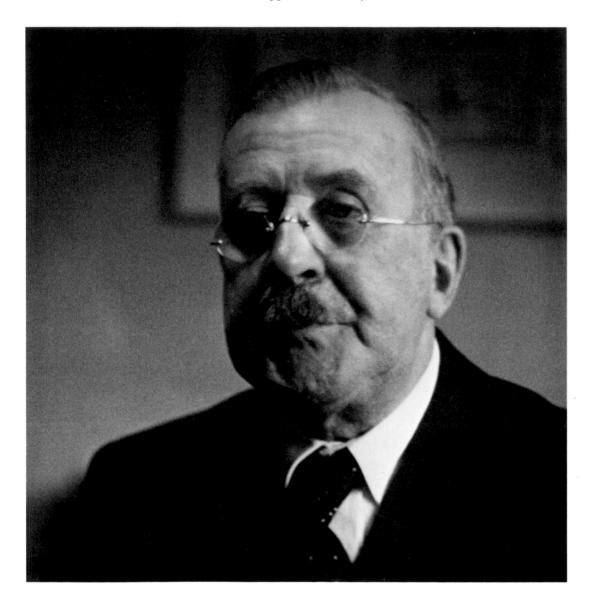

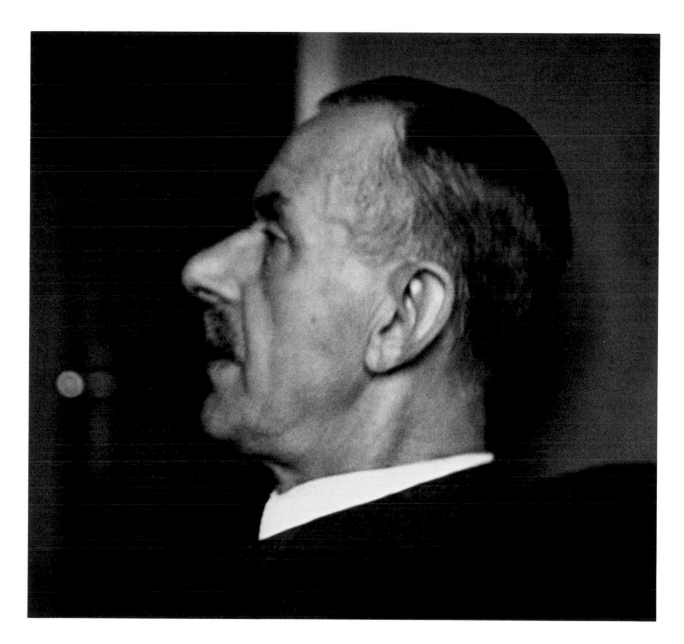

Thomas
Mann

During the war Mann gave frequent lectures in which he denounced the Germans and predicted the coming victory of Democracy. I was visiting Dorothy and Logan Clendening when his itinerary brought him to Kansas City and they gave him a formal supper party after his lecture. It made for important anti-Nazi propaganda and, like the others, was published as a small book by us. This was taken during that visit.

Henri de Montherlant

I was lunching with Jenny Bradley, the agent, and her client Henri de Montherlant, or rather they were lunching with me, at the Quasimodo restaurant on the Ile St. Louis in the summer of 1939. We published Montherlant but with no success, although we did publish at least one book by him after the war.

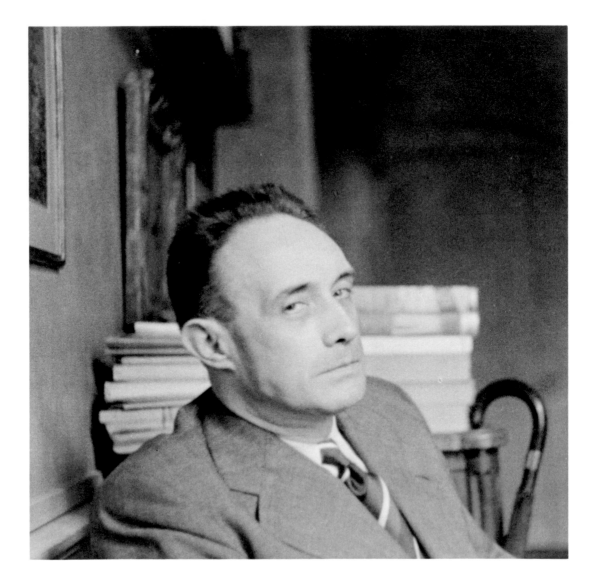

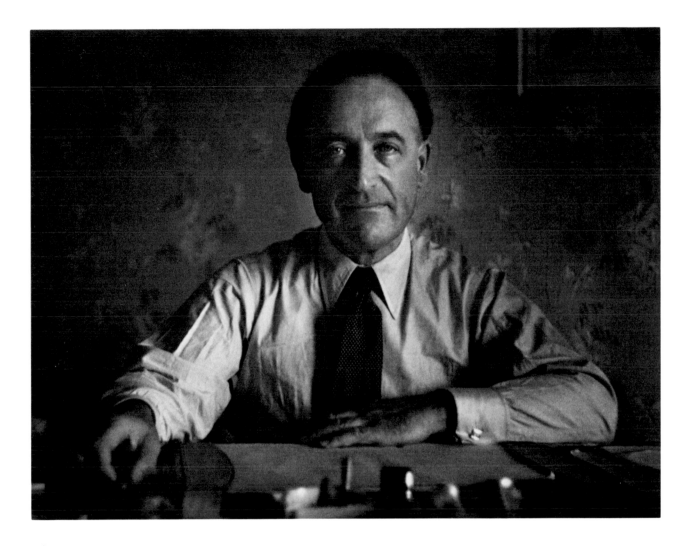

Jules Romains

Jules Romains and his wife Lise reached New York by ship in the summer of 1940. They settled at the Mayflower on Central Park West. Soon he had sold to the *Saturday Evening Post*, still in its days of glory, seven articles at three thousand dollars each, which we published later in book form as *The Seven Mysteries of Europe*. We grew very fond of Romains, who spent much time with us while the war lasted. He is here at his desk at the Mayflower.

Rebecca West

I was in London the fateful summer of 1939 and spent a weekend with Rebecca
West at the great house which her husband, a partner in the banking firm of
Schroeder, had taken for the summer. It was the estate of Britain's ambassador to
Japan. I remember a manservant unpacking for me and drawing my bath soon
after I arrived and much gloomy though lively talk among the guests about Hitler's
intentions. Since Rebecca, after her initial appearance on George Doran's list,
moved over to Viking, I don't believe we ever made a pass in her direction, because
like any author handled by Ben Huebsch she was bound to be devoted to him.

Aldous Huxley

In the summer of 1937 Aldous Huxley spent some time with very good friends of ours, William Seabrook, whose books were very successful (we were not his publishers), and his wife Marjorie Worthington, whose novels we did publish, at their place near Rhinebeck on the Hudson, where we often drove up to visit. It must have been tea time when I caught Aldous in a picture that shows clearly his failing eyesight.

André Gide

In the early summer of 1939 I had a tiny duplex penthouse in the delightful Hotel St. Regis on rue Jean-Goujon. There was a little balcony outside the sitting room. I remember the Spanish Liberal foreign minister, J. Alvarez del Vayo, for whom we had published a book, coming to see me there, and Gide too. The St. Regis was where I began and finished my first wine tour with Alexis Lichine in 1950, the next time I saw Paris.

André Maurois

Blanche was very fond of André Maurois despite the fact that one of our editors at the time rejected *Ariel*. I can't say that we foresaw what lay ahead for this French man of letters. But the three of us were having tea in the garden of the Ritz in Paris when I took this.

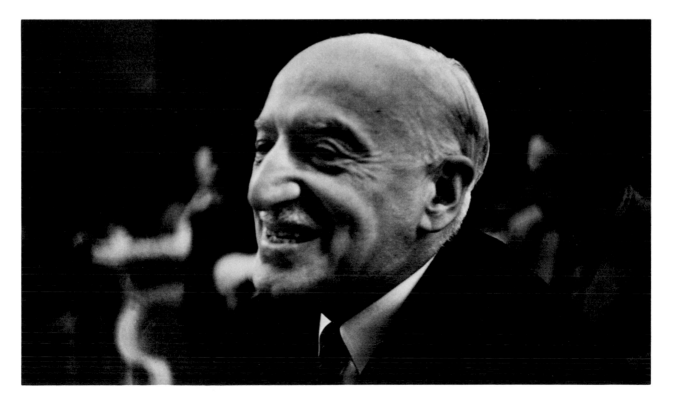

Walter
de la Mare

This shot of de la Mare was taken in his middle years when he lived out in the country. I think the village was called Slough. About 1912 I began reading and loving his poetry, and I tried to get him on my list almost as soon as I had one. But his agent, J. B. Pinker, would not take a chance on a young unknown house and took him, I think, to Henry Holt, as the firm then was. A few years later we did issue Jack's (that seems to me to be what his friends often called him) novel *Memoirs of a Midget*. He was a dear man with a widely ranging curiosity and used to ask the most outrageous royalties with a smile that was adorable—as naive as that of a young child.

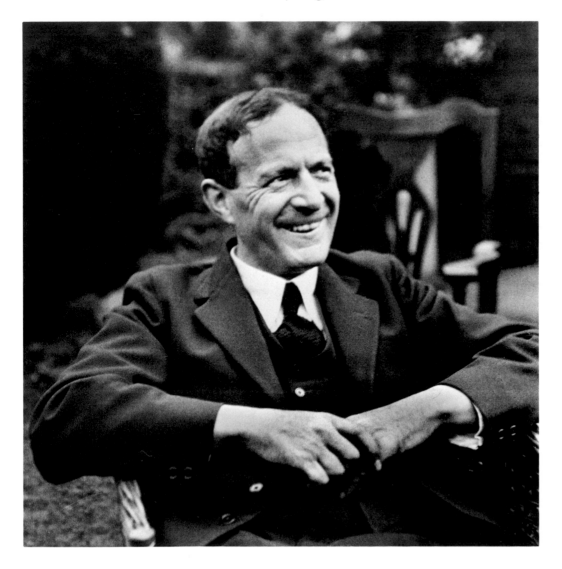

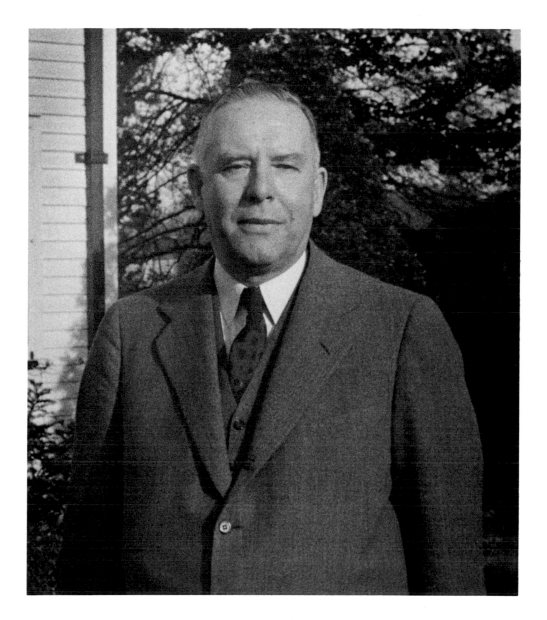

Wallace Stevens

We had published Wallace Stevens for many years before we met. But finally once when I was in Hartford I called on Stevens at his office at the Hartford Accident and Indemnity Company, of which he was a vice-president. Stevens was shy and/or worried about how his business associates would view his extracurricular activities and was concerned that he might be awarded a Pulitzer Prize. We drove to his home and spent an hour or so walking about the grounds and chatting. I do not think he took me into the house.

Norman
Rockwell

It's Norman Rockwell, and I must have met him
in Vermont—it would, I'm pretty sure, be in Arlington
because our friends Bob Haas and Dorothy Canfield
had homes there. But when? I can't guess.

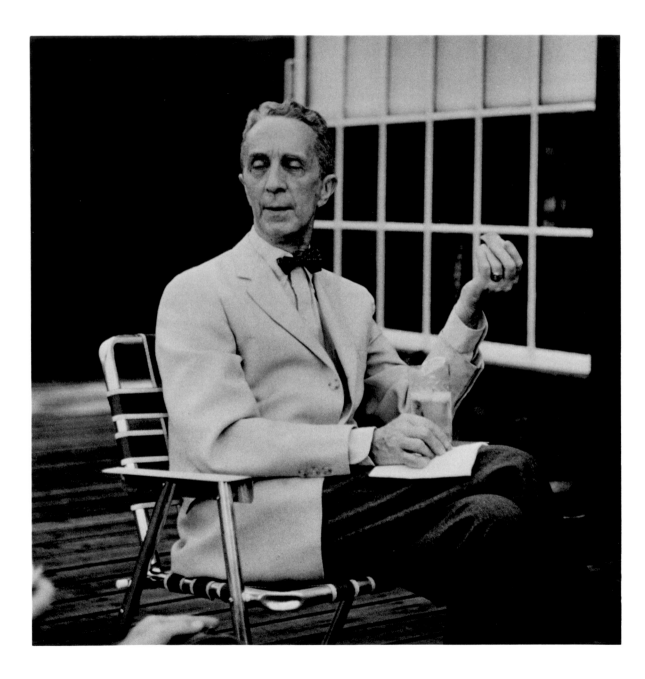

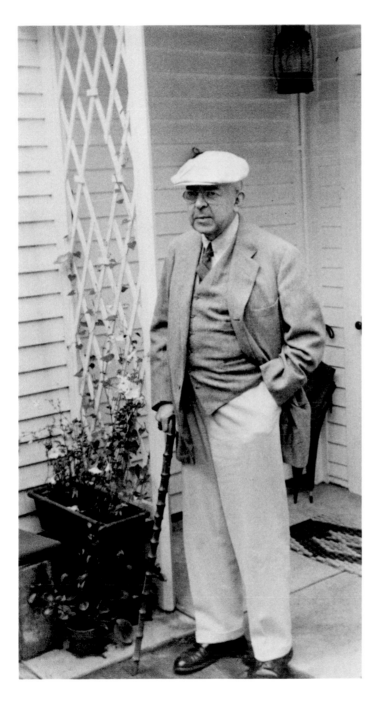

John Munro Woolsey

John Munro Woolsey was a wonderful man and a fine judge. I feel fortunate to have had him as a friend for many years. He will always be remembered for his famous *Ulysses* decision, itself a small work of art in which he took great pride and satisfaction. Once he had a long-drawn-out case before him, and he felt it would be fun to hear as much of it as possible during the summer in his home at Petersham, Massachusetts, where he turned a tiny building on his grounds into the courthouse. It was in 1940 during one of my visits there that this snapshot was taken.

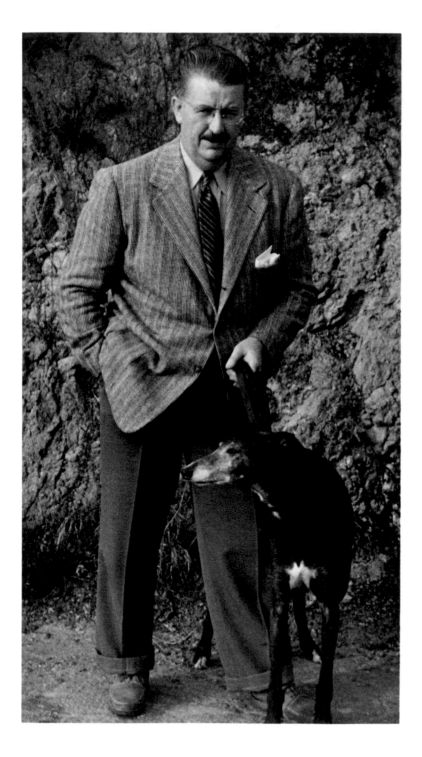

W. R. Burnett

We published W. R. Burnett's novels for many years, from 1938 to 1958. Whenever I went to Hollywood we lunched together. This was taken early in 1940 at Glendale with one of his dogs, before he settled in a big house in Bel-Air. Our relations were always pleasant—I can't remember a single serious argument between author and publisher about terms, advertising, or anything else—but we never became intimate.

Robert Nathan

During much of the summer of 1937 Blanche and I spent alternate weeks at a cottage we had rented on the Cape and our small duplex in the Dorset on West 54th Street. The Robert Nathans were at Truro that summer; we saw one another frequently, and this was one result.

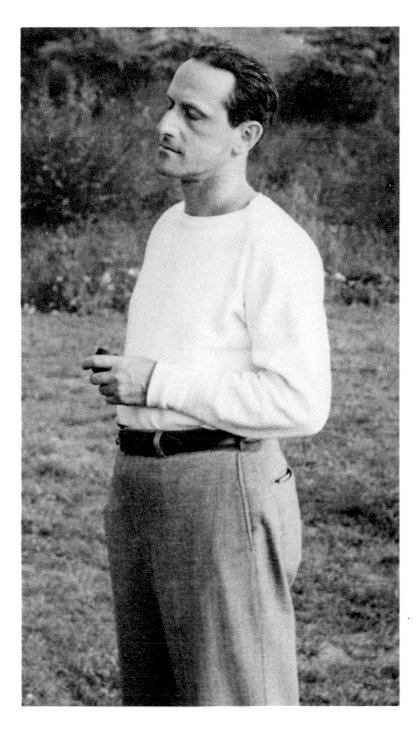

30

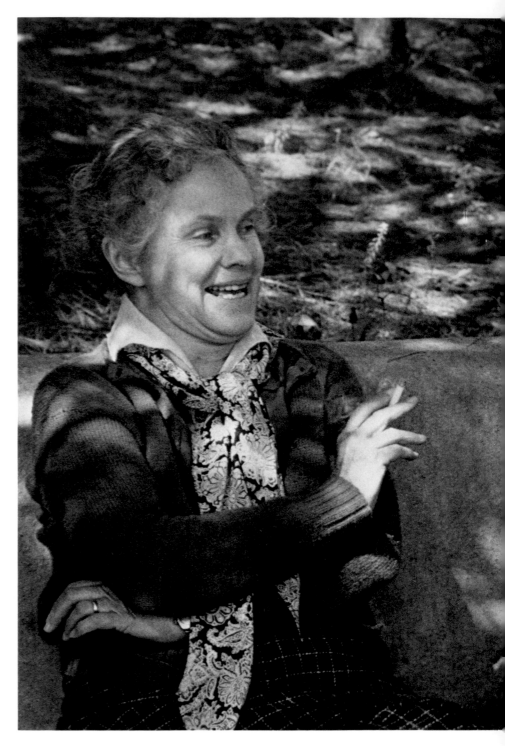

Dorothy
Canfield Fisher
and
Blanche W.
Knopf

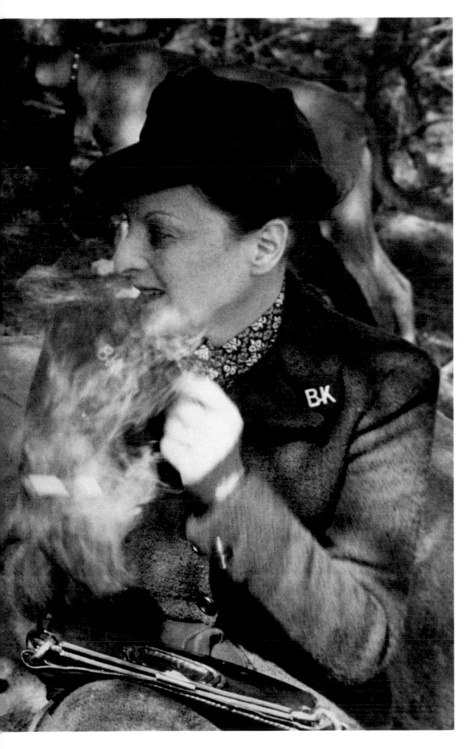

When I was a freshman at Columbia
in the fall of 1908 my appointed
adviser was Dorothy Canfield's father,
James H., the University Librarian. To
me he was a wonderful old gentleman
and friend. Decades later, when
Dorothy had become a popular and
gifted novelist as well as a respected
writer on educational matters, she
became fond of me (though we saw
each other but rarely). I always felt it
was just because I had known and
admired her father. In any case, one
day driving north in New England,
Blanche and I stopped at Arlington,
Vermont, where Dorothy Canfield
Fisher lived. I took this while she
and Blanche chatted in the shadows
of the trees.

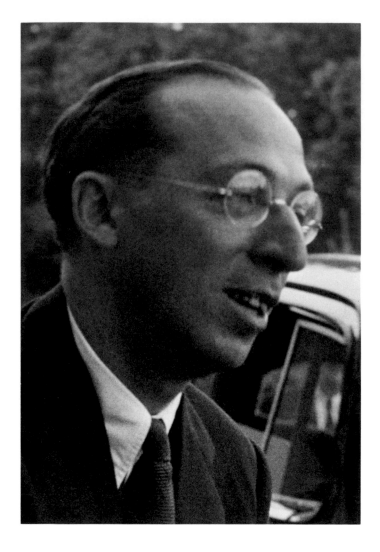

Aaron Copland

Aaron Copland was a young man when I took this of him at Tanglewood in Lenox, where Koussevitzky was the undisputed head of state. It seemed to Blanche and me that wherever Serge was, there was Aaron, of whom I can only say now, "We knew him then." And we admired him too, even if we did not foresee for him the future that I am sure the master did.

Myra Hess

In July 1939 I was in London. Myra Hess was one of our closest English friends, and this was taken of her at her London home.

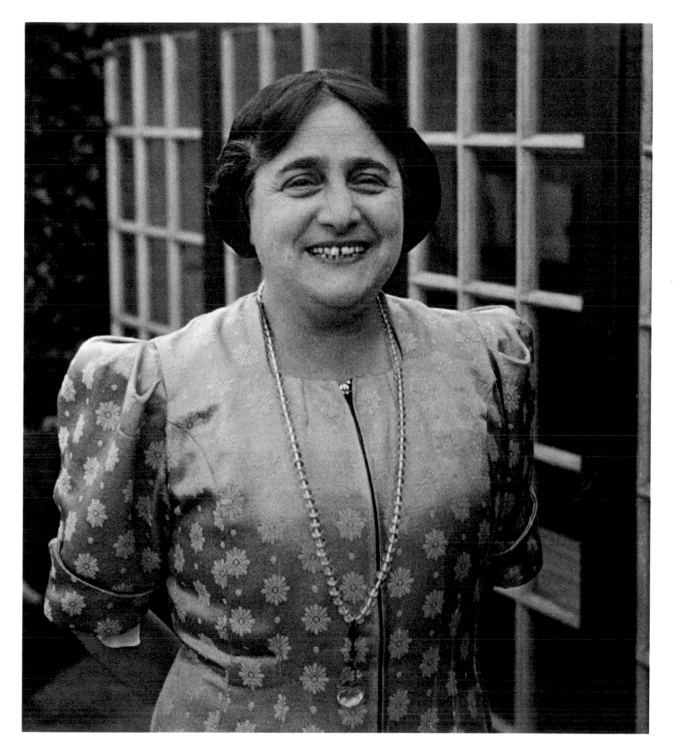

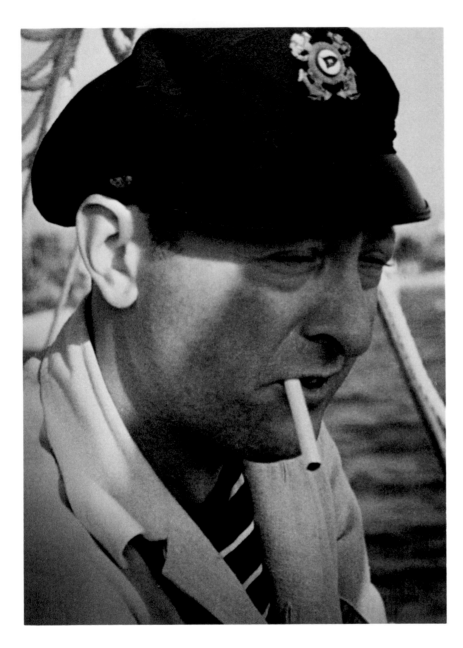

Jascha
Heifetz

In the summer of 1938 Jascha and Florence Heifetz had a cottage in Balboa, California, where Jascha kept a boat of which he was very proud. We paid them a brief visit, and I caught Jascha in this very uncharacteristic pose.

Boris Karloff

Blanche had a succession of Yorkshire terriers—the last of them, Monsieur, is still alive in March 1975 at an age that in man would be 105. One of his predecessors is cradled here by Boris Karloff, actor-friend of our Purchase neighbors the Howard Cullmans.

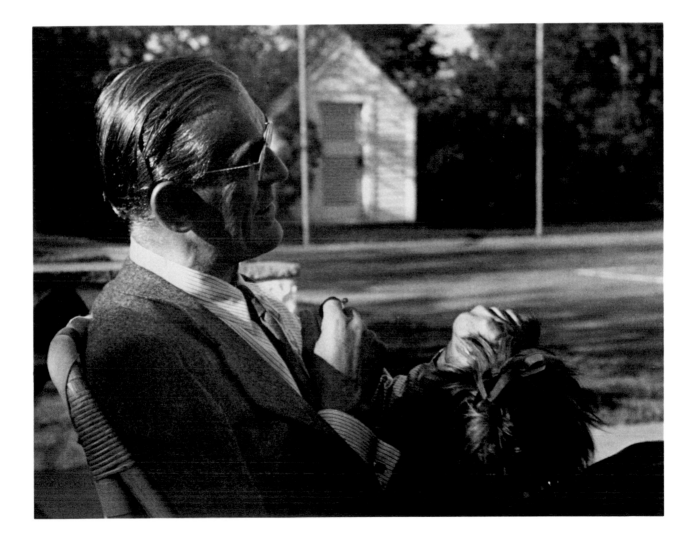

Serge Koussevitzky

When Koussevitzky came to Boston to take over its great orchestra for what turned out to be a quarter-century, Blanche and I were among the very few acquaintances he had in America. We were at Tanglewood when he attempted three times in vain to make the Valkyries ride out the violent storm that burst over the great tent, which he vowed he would never conduct in again. And so Saarinen's shed came to be built. He acquired his beautiful estate, Saranak, and there he presided as host at many a memorable meal. He liked to wear full double-breasted white flannel suits with beret to match. His first violist was married the morning I took this picture of my dear friend, of whom it might be said, as I think it once was of Teddy Roosevelt, that at a wedding he wanted to appear as the groom and at a funeral as the corpse.

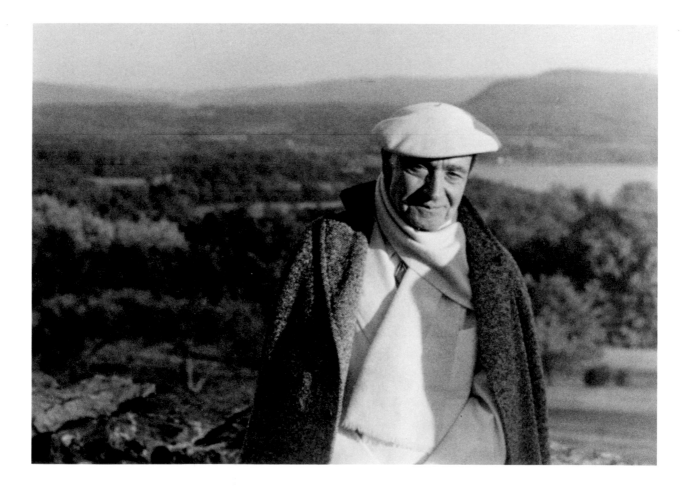

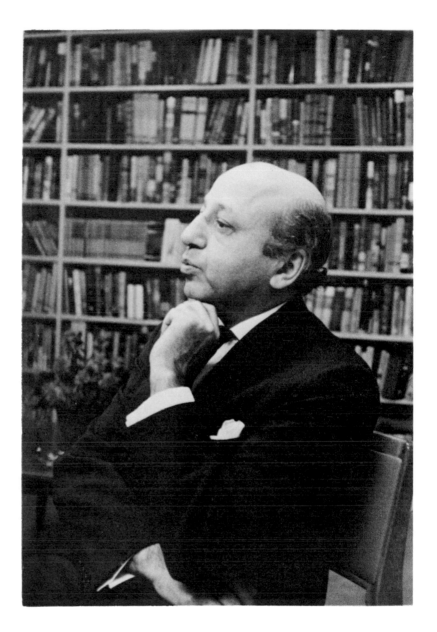

Yousuf Karsh

I was an early admirer of the work of Karsh and discussed more than once with
him and his wife the possibility of our doing a volume of his superb photographs
of famous men and women, which Nelson eventually published with great success.
I thought it amusing to the point of impudence for me to produce this likeness of
him in my office.

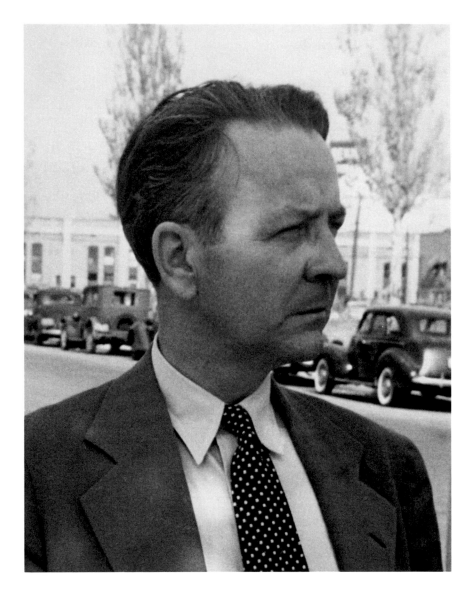

Raymond Chandler

Although we published four of Raymond Chandler's novels and he always lunched with Blanche or me when we were in Los Angeles, no close friendship ever developed between us. It was after one of these lunches in 1940 that I took Ray just before he got in his car to drive away.

Eric Ambler

In midwinter 1937 I had a flat in Cork Street, London, which I remember well because of the strange contraption—I think the English called it a geyser—which supplied hot water for the bath. And it was in the bath that I began reading a wonderful mystery by a new name: Eric Ambler. I accepted *Background to Danger* immediately and we published it (those were the days!) in August. Then after 1939 a succession of beautiful Amblers until, through 1963, nine had appeared over our imprint. During the war Eric was in the States a good deal of the time. He made many weekend visits to Purchase, and here he is in 1944 in undress uniform, sitting between our pool and the house.

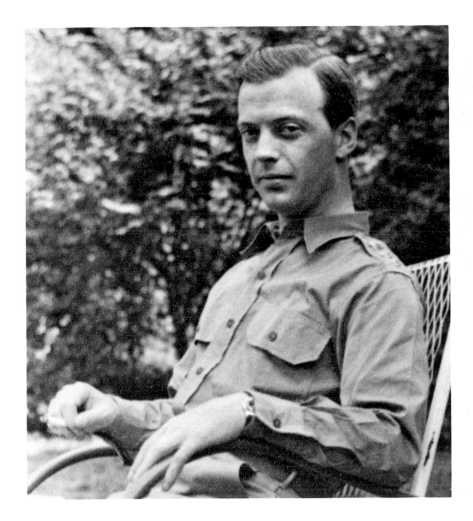

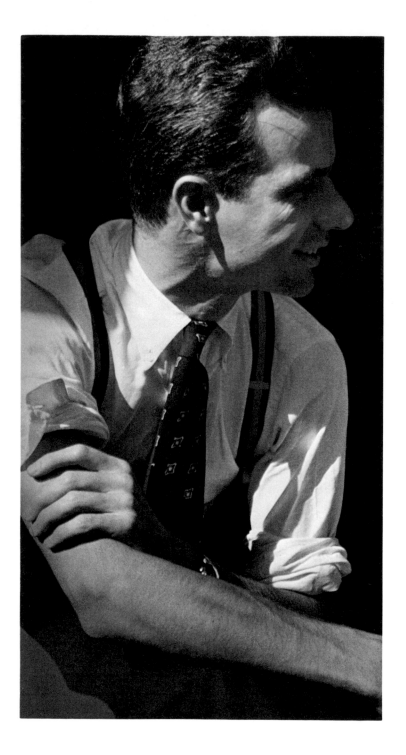

John Hersey

This was taken on an early, perhaps the first, visit of the Herseys to Purchase, and not long after the publication of John's first big success, *A Bell for Adano*. He is sitting on the steps outside the sunroom, and from his dress and the light it must have been an uncommonly warm day for March. I had read John's manuscript at a sitting but, since he was still an active war correspondent, asked when I called to tell him how much I liked and admired his novel, "Will this be good for your business?" He answered quickly, "Will it be good for yours?" Well, it turned out to be very good for both of us.

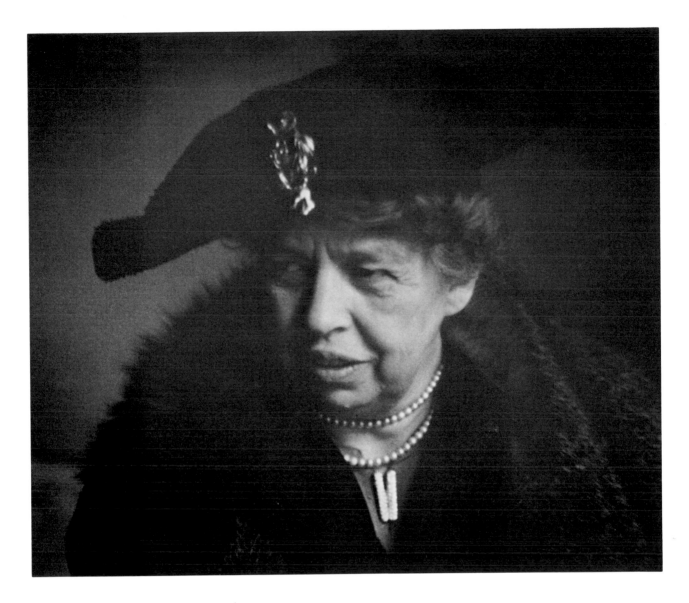

Eleanor Roosevelt

In 1940 we published *Christmas*, a tiny story for youngsters by Eleanor Roosevelt, who had had us to dinner once at the White House. So one day she came by 501 Madison. I well remember the stir that went through the office as she passed by girl after girl. She was completely unselfconscious—possibly not even aware that I was snapping her as she sat talking with Blanche at her desk.

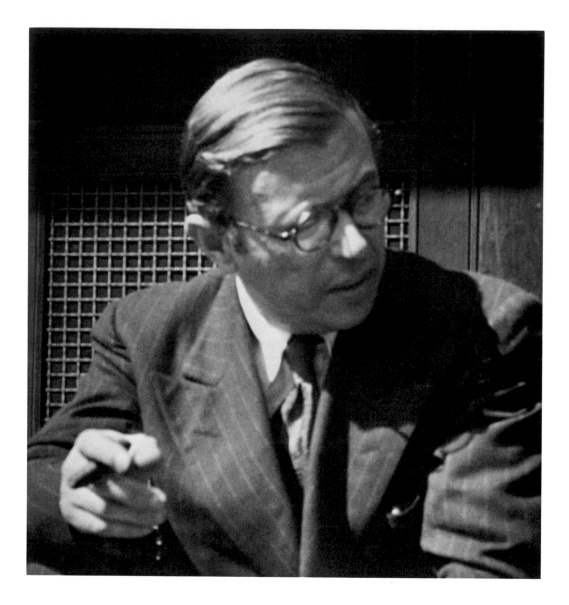

Jean-Paul Sartre

Blanche reached Paris soon after our troops at the end of World War II. Jenny Bradley helped her secure Camus, Simone de Beauvoir, and Jean-Paul Sartre for our list at that time. Later in 1945 Sartre came to Purchase for lunch one Sunday, and here he is on the steps leading into the sunroom.

Albert Camus

When Albert Camus was awarded the
Nobel Prize in 1957, Blanche said, "Let's
go to Stockholm for the ceremonies." I
said, "Let's," and we went. I flew directly
to Stockholm—was amused and embar-
rassed when a passenger spoke to me as
if I were one of the prizewinners—while
she flew to Paris to join Camus and his
wife and the Michel Gallimards. But
the weather was so bad that they had to
come on to Stockholm by train. We were
all richly entertained for several days
and nights, Blanche was able to spend
many hours discussing Camus' next
book with him and reading some of the
work in progress, and I took this one
sunny morning outside the Grand
Hotel.

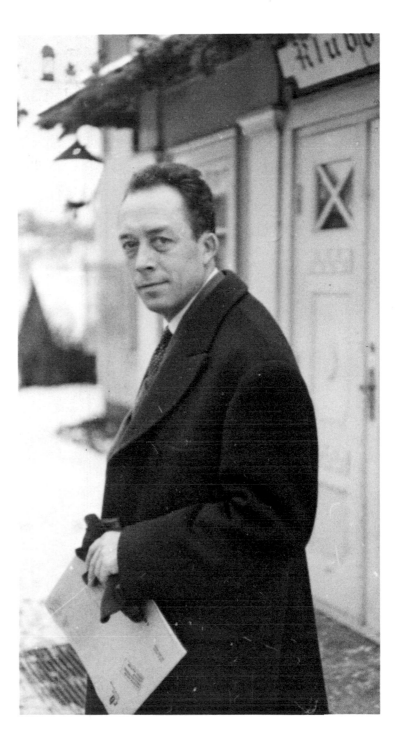

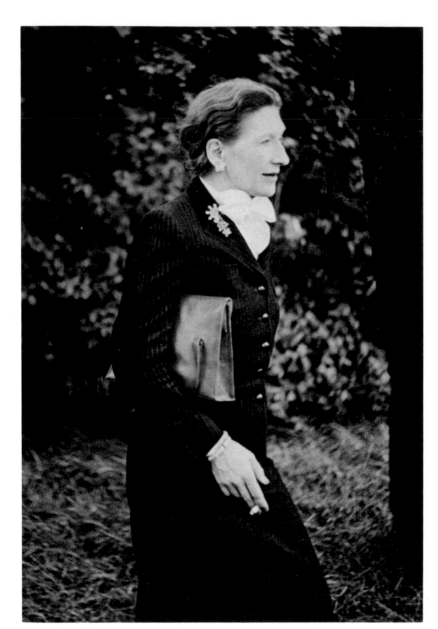

Elizabeth Bowen

While Elizabeth Bowen's husband Alan Cameron was alive they lived in a fine house off Regent's Park, where we saw them whenever we were in London. One day in 1946 I asked her to come outside the house—perhaps over to the park—and this, which I think is very good of her, is the result.

William Maxwell

This was dear Bill Maxwell at Purchase in June 1958, when the flowering crabs and the perennials behind him were all in full bloom.

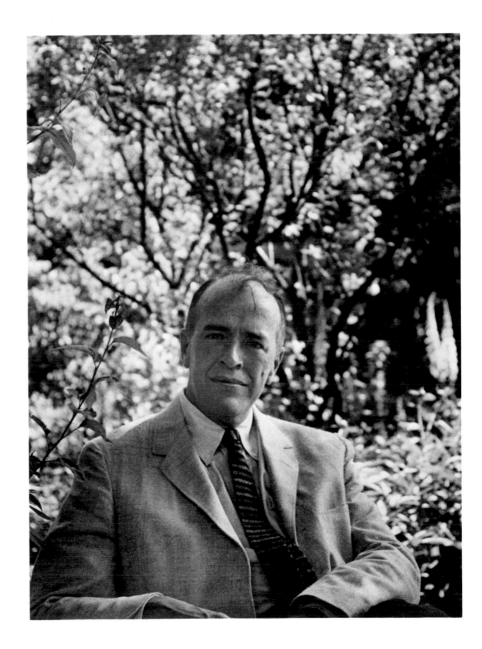

I. J. Singer

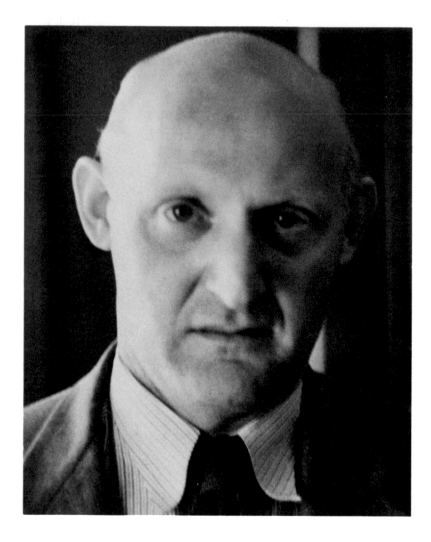

In 1934 or '35 someone called to my attention a long novel that had been running serially in the *Jewish Daily Forward*. Maurice Samuel did his usual superb translation, and in 1936 we published *The Brothers Ashkenazi* with a very substantial success. It was dramatized, and Arthur Rubinstein wanted to see it and did. He and his wife Nela came to the apartment for supper and to meet Singer. There was a passage in the novel and the play in which Polish soldiers treated some poor Jews with great brutality. Arthur was enraged. "You can't say Poles treat Jews that way. Just see how they treat me." And the two were off. Poor Singer finally ended it. "Mr. Rubinstein, please stick to your art, which is very great, and leave my writing to me." Acutally, Singer was one of the kindliest men I have ever known. Here he is in my office sometime before his death in 1944, and I think it a very good likeness.

In 1936 we published *Early Americana*, a collection of stories by Conrad Richter. Next time I went West, in 1938 I think, I stopped over at Albuquerque to meet Conrad. That meeting began a friendship that lasted until his death. He was a Pennsylvanian—his home was at Pine Grove, not far from Harrisburg—but he settled in the Southwest for some time because of his wife's health. He is here, I think, rocking on the piazza of the old Fred Harvey Hotel in Albuquerque.

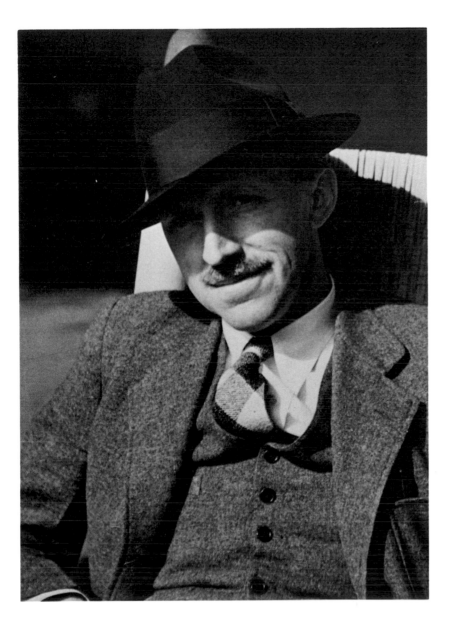

Conrad Richter

Ivy Compton-Burnett

Ivy Compton-Burnett came around to Claridge's for tea one afternoon in 1950. We were then her American publishers. French doors opened onto a sort of terrace outside our living room, and I took this snapshot there.

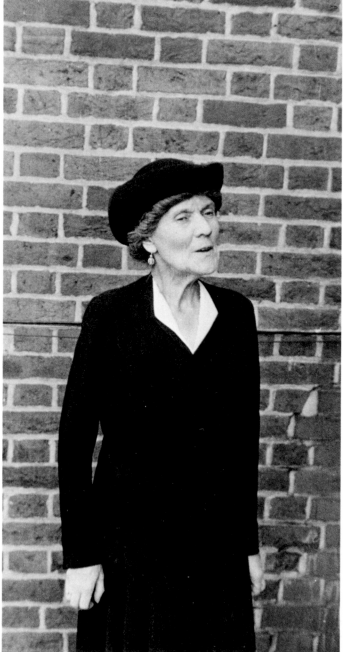

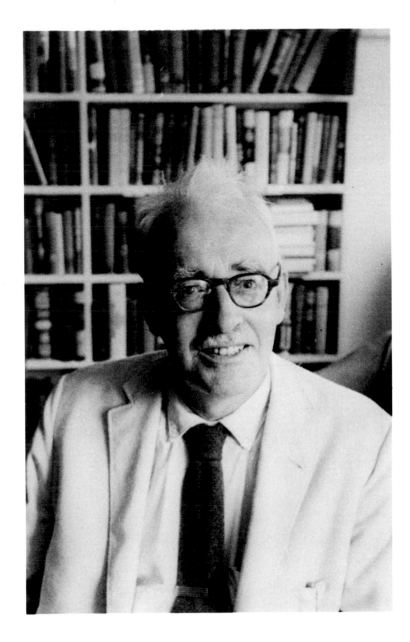

Frank O'Connor

We made it with Frank and he with us the long hard way. It began with a novel, *Dutch Interior*, a resounding failure in 1940. Eight years later *Crab Apple Jelly*, a collection of stories, and *The Common Chord*. After that the caissons began to roll and long before his death in Dublin in 1966 he had won a devoted and substantial American following.

Shirley Ann Grau

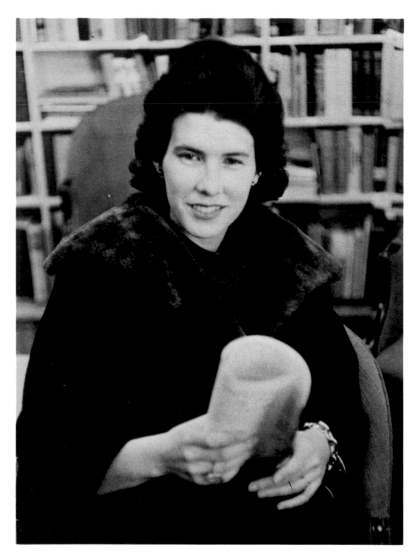

Sometime around 1954—perhaps earlier— *The New Yorker* began printing short stories by Shirley Ann Grau. One day at lunch at the St. Regis her remarkable agent, Bernice Baumgarten, strongly recommended Shirley Grau's *The Black Prince and Other Stories.* I said I would accept it right then and there. She refused to let me commit myself until I had read the entire manuscript. Needless to say, I didn't change my mind, and we published Shirley's first book in 1955. There followed four fine novels, the third of which, *The Keepers of the House*, won the Pulitzer Prize in 1965. I have seen her mostly in New Orleans, where she lives with her husband, the philosopher James Feibleman. But this picture was taken in my office in late 1963.

When it became known early in 1963 that Muriel Spark was going to leave the publishers with whom she had issued several fine novels—notably *Memento Mori*— the chase was on. Blanche finally succeeded in meeting her terms, and in 1963 we published *The Girls of Slender Means* and two years later *The Mandlebaum Gate*. I hardly knew Muriel in those days, but she did come to my office for this snapshot.

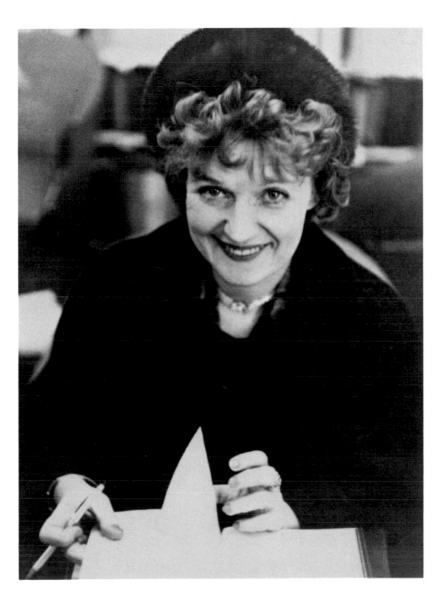

Muriel Spark

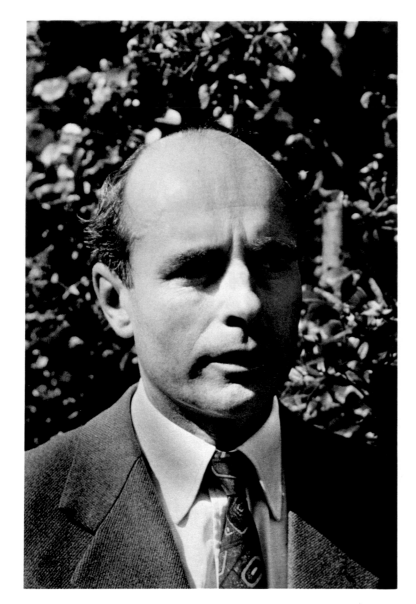

Hammond Innes

One Sunday in 1962 Blanche and I drove out to Kersey, Suffolk, England, to have lunch with Ralph Hammond Innes and his wife Dorothy. Their home is an ancient one, and Dorothy's flower gardens were of surpassing loveliness.

Early in 1952, Blanche and I were in Dallas, and Stanley Marcus's wife, Billie, gave me an issue of *The New Yorker* which she said she had kept for me because of a story in it called "Taste." It was an unseasonably hot spell—up in the eighties—and back in my hotel I stripped, lay naked on my bed, and read this best of all wine stories by Roald Dahl, of whom I had never heard. Our office informed me that his agent had already submitted a manuscript by Dahl but that as it was a collection of short stories we had politely turned it down. I wired back that we would most certainly publish anything that contained "Taste." And so my long association with Roald began, to the pleasure of us both. He began coming to Purchase occasionally—he shared my love of good wines—and here he is with the first of the two boxers Blanche and I owned.

Roald Dahl

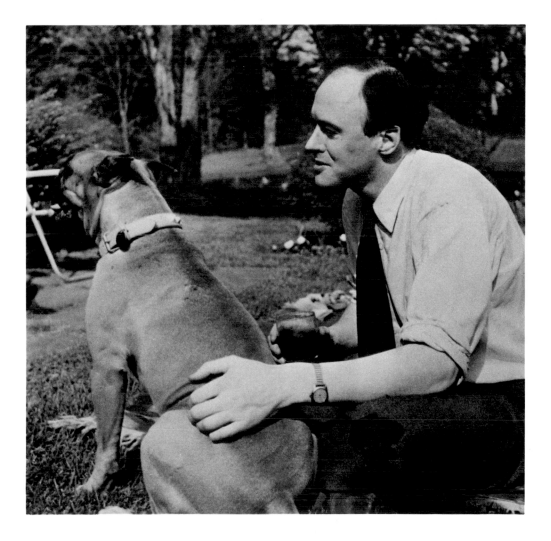

Kenneth Millar (Ross Macdonald)

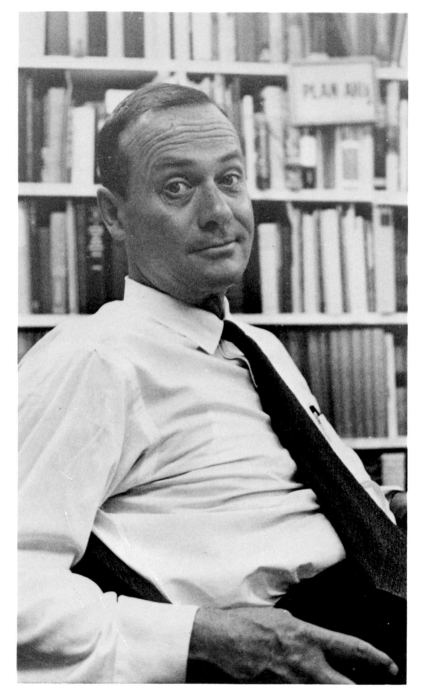

We published *The Moving Target* in 1949. Ken has always taken life and his work very seriously (he's a great environmentalist, and oil has become a very dirty word in his vocabulary since the great Santa Barbara spill in 1969) and wanted from way back to be regarded as a serious novelist and not just a writer of detective stories. He persisted, and with *The Goodbye Look*, which was given a front page rave review in *The New York Times Book Review*, he broke through the sound barrier, his sales quadrupled, and he achieved exactly the success he had so long deserved. We have never found a difference between us worth even arguing about, and this picture taken in my office in 1965 is one of the best likenesses I've gotten of anyone.

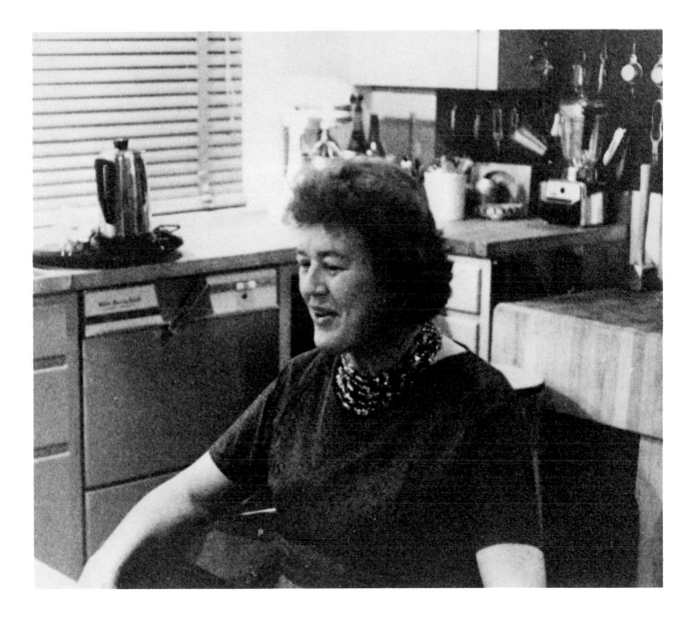

Julia Child

I went to dinner at the Childs one night in May 1965, and we ate in their kitchen-*cum*-dining room. As with so many of my snapshots of people, the indoor light was inadequate (needless to say, the food was not!) and there was no attempt at posing the subject.

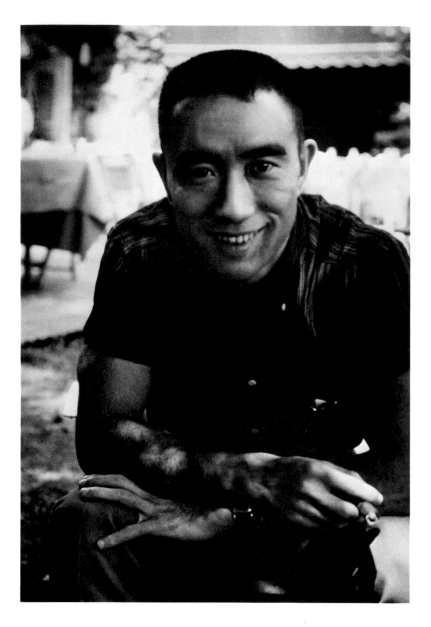

Yukio Mishima

In 1964 Yukio Mishima, the most popular of the many Japanese novelists Harold Strauss nursed in English translation for us, visited New York. Harold brought him to lunch at Purchase one day, and this was taken at the Century Country Club!

Yasunari Kawabata

I left Harold Strauss's Japanese authors to his exclusive care, since he alone was responsible for our fine list. The only exceptions were the young Mishima and the aging Kawabata, whom I met in my office for the first and only time in May 1960.

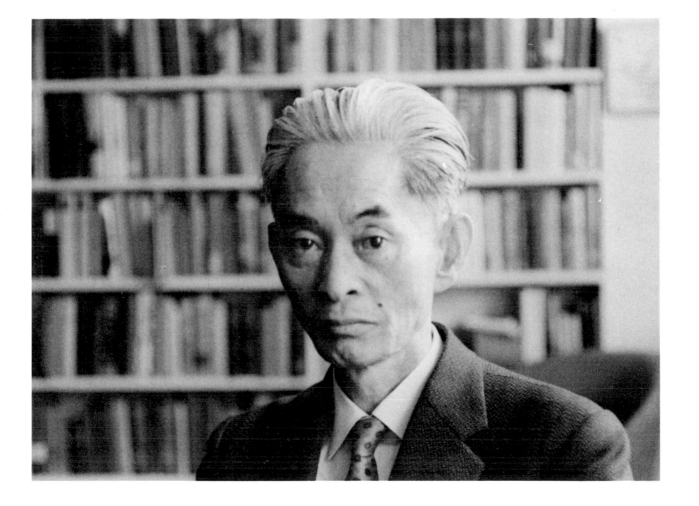

Jorge
Amado

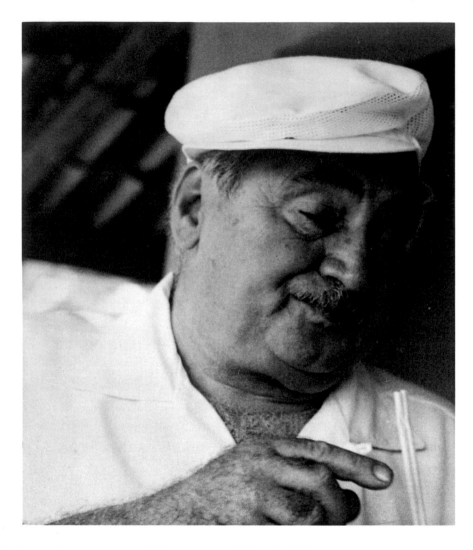

Jorge Amado is a nonesuch—big-hearted, generous, and the warmest of friends. We met first in Salvador, the capital of his native state of Bahia, Brazil, in 1962, the year of my seventieth birthday, which it so happened was marked by a small dinner given me by old friends in London. Jorge, in his cabled congratulations, asked, "Why London?—Why not Salvador?" In the summer of 1969 we were in Brazil, and he was so insistent that we celebrate *his* birthday with him in Salvador that we had to meet his wishes. It was quite a day. A great gathering at his home at noon for drinks and food that served only as an overture to an al fresco feast at a restaurant in the suburbs, then to our hotel for a nap, and finally, twenty-five kilometers out of the city, to a *condomblé* with all its frenetic dancing and black magic rites, until I begged to be taken home to our hotel and bed.

In recent years we have tried but not always succeeded to pay at least a brief visit to John and Barbara Hersey at their old-fashioned but wonderfully comfortable house on Martha's Vineyard. Lillian Hellman lives nearby, and one afternoon in September 1967 we had drinks with her on our way to dinner. This snapshot, I think, turned out exceptionally well.

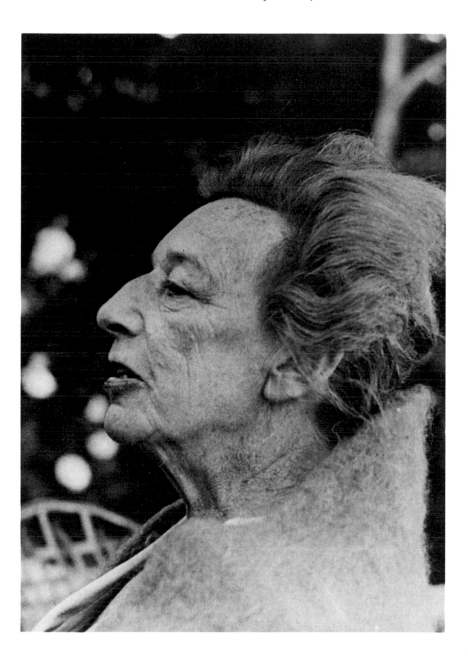

Lillian
Hellman

John Updike

John appears here as a very young man, as indeed he was. And only at the beginning of his long and joyous association with the house. He was in my office in 1960. We had published *The Poorhouse Fair* in 1959 as well as a collection of short stories and a year later brought out his sensational *Rabbit, Run* and were off on an association that has been (a favorite word of Carl Van Vechten's) "perdurable" and tremendously profitable. Our paths have not crossed as often as I would have wished, but John has a habit of flitting in and out of the city, leaving behind him only manuscripts and proofs and our renewed astonishment at his capacity for what must be work as difficult (or it may, for him, be easy) as it is voluminous and scintillating.

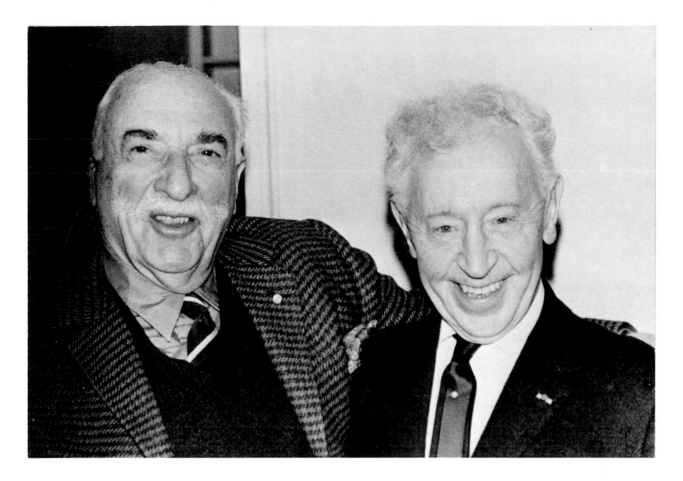

Alfred A. Knopf
and Arthur Rubinstein

This snapshot of me with the great man was taken at the Rubinstein apartment at the Drake in New York by Helen Norcross Hedrick, whom I married in 1967, some time after Blanche's death. I first heard Arthur in Vienna in 1912. We have been close friends since Blanche met him and his wife Nela who were fellow passengers on her crossing to New York in 1937.

A Note
About the Type

The text of this book was set in Olympus, a film version of Trump Mediaeval. Designed by Professor Georg Trump in the mid-1950's, Trump Mediaeval was cut and cast by the C. E. Weber Typefoundry of Stuttgart, West Germany. The roman letterforms are based on classical prototypes, but Professor Trump has imbued them with his own unmistakable style. The italic letterforms, unlike those of so many other typefaces, are closely related to their roman counterparts. The result is a truly contemporary type, notable for both its legibility and its versatility.

This book was composed by TypoGraphic Innovations, Inc., New York, New York; printed by Rapoport Printing Corporation, New York, New York; and bound by A. Horowitz & Son, Clifton, New Jersey.

The book was designed by Earl Tidwell.